This journal belongs to: